beach beauties

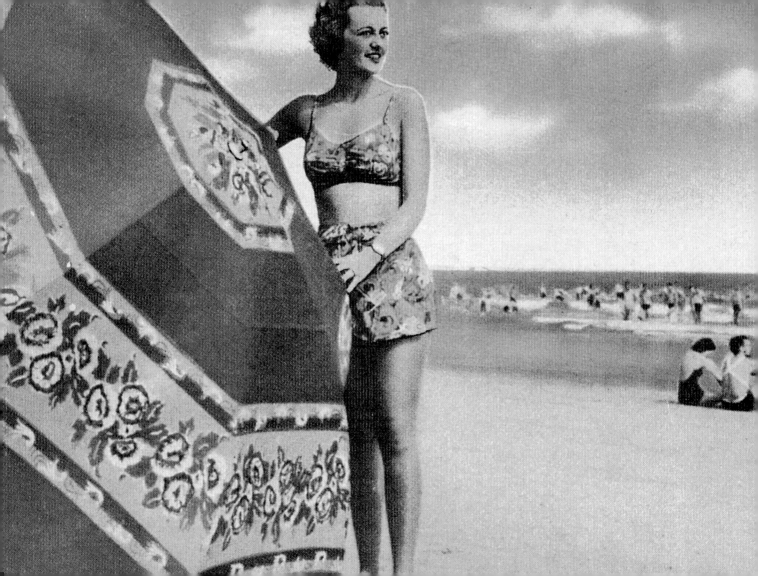

by Beth Dunlop

STEWART, TABORI & CHANG

beach beauties

POSTCARDS AND PHOTOGRAPHS, 1890–1940

NEW YORK

Published in 2001 by
Stewart, Tabori & Chang
A division of Harry N. Abrams, Inc.
115 West 18th Street
New York, NY 10011

Dunlop, Beth, 1947-
 Beach beauties: postcards and photographs, 1890-1940 / by Beth Dunlop.
 p. cm.
 ISBN 1-58479-062-8
 1. Pinup art—United States. 2. Bathing beaches in art—United States.
 3. Postcards—United States—History—20th century. I. Title.

NC1878.E7 D86 2001
760'.04424'0973—dc21
2001016224

The text of this book was composed in Trade Gothic.
Printed in Singapore
10 9 8 7 6 5 4 3 2 1
First Printing

Design by Nina Barnett

acknowledgments

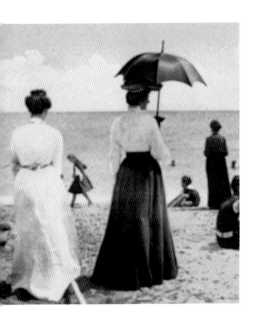

With deepest appreciation to Hugh Christie, Margaret Doyle,
Karenellyn Duncan, Ruth Jasper, Helen L. Kohen, David Leddick,
Clemmer Mayhew, Joan Morris, Bruce Siegel, Dennis Wilhelm.
To my husband, Bill Farkas, and son, Adam Farkas, for putting up
with all my "bathing beauties."

And to Sandy Gilbert and Emily Von Kohorn at Stewart, Tabori & Chang:
to Sandy for seeing the whimsy, joy, and substance of these photos and
postcards, and to both of them for nurturing words and images into a book.
To Nina Barnett for her imaginative design.

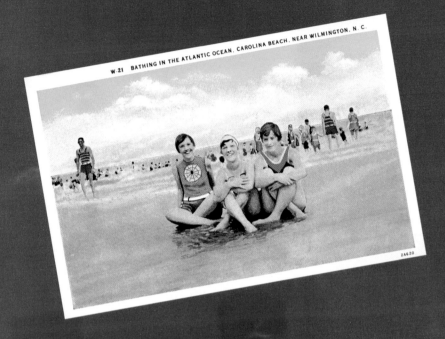

contents

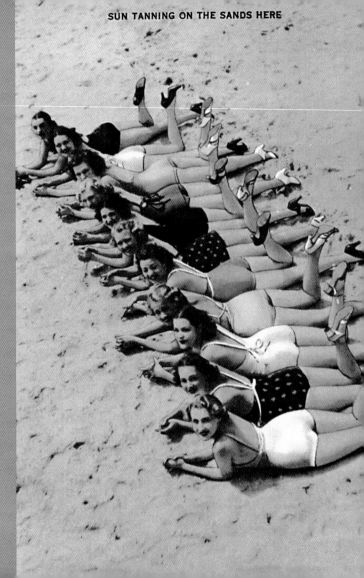

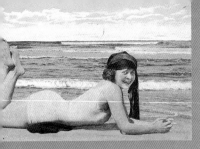

introduction

It started with a single postcard picked up at a flea market, five women in old-fashioned bathing suits romping through the surf. I put it up over my desk because it was so joyful, so ebullient. But as happens with those of us given to accumulating, one good postcard led to another. Soon I had a handful, then more and more until it was a full-fledged collection—postcards mostly but also snapshots and professional images. While other collectors seemed to prize the formal, posed, seductive photos from Europe (mostly from France, Belgium, and Germany) showing the early years of the century, I was drawn to American images, for their naiveté, their impromptu high spirits, and their overall cheerfulness. I found a certain assurance in them, a connection to them.

As I acquired more postcards and photos, I began to perceive their lineage, which, in a way, was part of my heritage, too. I saw in these images reflections of my mother in the waning days of the Depression, my grandmother in the years surrounding the First World War, and my great-grandmother at the turn of the twentieth century.

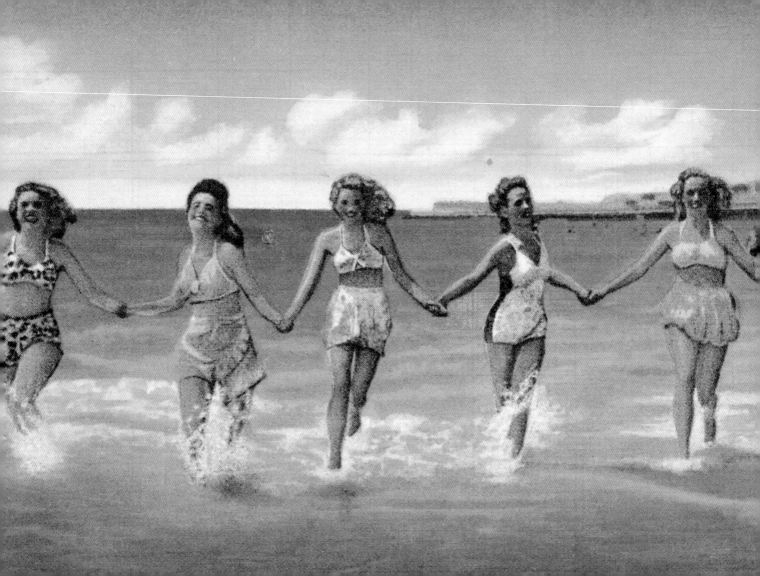

These images constitute not just an ode to women at the beach, but also an evocative social document. The photographs shown on these pages—posed or spontaneous, sober or giddy—depict women coming into their own. They are the very picture of emerging freedom.

In the early years of the century, Americans became obsessed with postcards. In 1907–8, the U.S. Post Office reported mailing almost 678 million postcards. This postcard boom was the result of several developments. First, the passage of the Private Mailing Act of 1898 freed Americans to send and collect images through the mail. Second, the Eastman Kodak Company introduced a "Folding Pocket Kodak" camera in 1906, which allowed customers to have their pictures printed directly on postcard stock. Then, in 1907 Americans were allowed to write messages on the postcards; previously picture postcards could only feature the address of the recipient.

These events launched what is considered the "Golden Age" of postcards (roughly from 1907–1917). "Golden Age" postcards ranged from professionally produced artwork and photographs to candid shots. These postcards are prized today for their quality and artistry, but they are also topical, informative, and even humorous, offering a glimpse of the daily life of the nation. Americans collected postcards, but their primary use was for simple and direct communication. After all, without E-mail, fax machines, and telephones, postcards were the quickest means to get in touch with family and friends.

Of course, postcards are notoriously unreliable. While they can serve as the cultural historian's dream, they are also sometimes creative works of fiction. Images from the early years of the century show up on postcards manufactured much later; bathing beauties from the 1930s were still in circulation in the 1950s, which might lead one to assume the prevalence of a particular style or value. Indeed, in some cases, the same image shows women in ever-skimpier bathing suits—the excess fabric (skirts, midriffs) simply airbrushed out to keep the costume current.

Still, with a keen eye we can use postcards to trace general developments in women's appearance on the beach. Before the turn of the twentieth century, women sat seaside fully clothed. They were clad head-to-toe in heavy woolen garments and shaded by parasols. Hats were de rigueur in the early years of the century. Those cumbersome clothes gave way to nautical dresses with bloomers and stockings underneath. Hemlines went up and necklines plunged, though on many American beaches modesty still ruled and "censors" with measuring tapes roamed both beaches and boardwalks to make sure that bathers were wearing appropriate clothing.

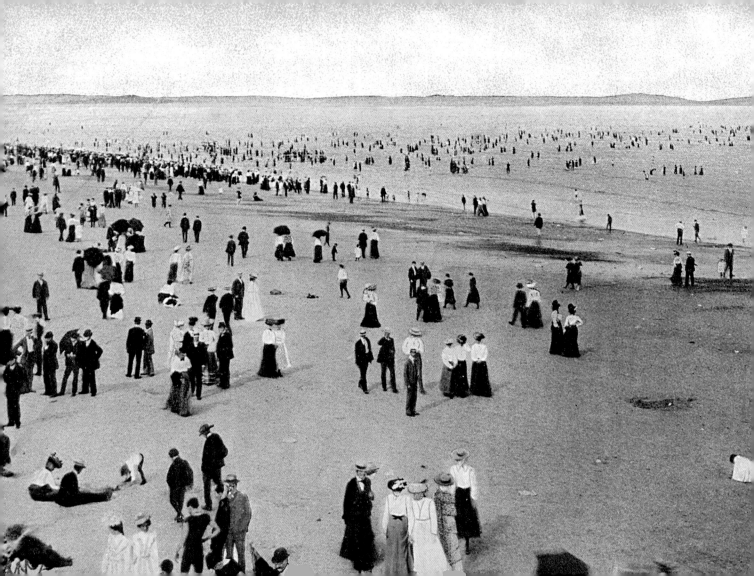

No **recreation** or sport, and it is both,

has the number of **devotees** that bathing

in the **surf** attracts. . . . Several miles this

wonderful beach extends, so that

thousands at the bathing hour can disport

themselves and no one is **crowded.**

—Miami Beach Promotional Brochure, 1920s

Soon the bathing "costume" (either owned or rented at popular beaches) gave way to the swimsuit, an invention attributed to the Australian swimmer Annette Kellerman, the first woman swimming star. Swimsuits were made popular by magazines, advertisements and celebrities—from suffragists to starlets. Mack Sennett's silent Keystone Comedies brought the bathing beauty to the big screen, starting with *The Diving Girl*, made in 1911. The movies created such stars as Mable Normand, Louise Fazenda, Phyllis Haver, and Gloria Swanson. These American icons even appeared on "arcade cards," novelty items which featured famous people and which were available for purchase along many a beach boardwalk.

The evolution of fashion is not the only thing one can trace with postcards. The images show us an emerging confident and free American woman, capable of shedding inhibitions as well as weighty garments. Under scrutiny, the photographs and postcards reveal a growing self-assurance, a buoyancy (beyond the inevitable swimming prowess that came with the shedding of all that fabric), and a pride.

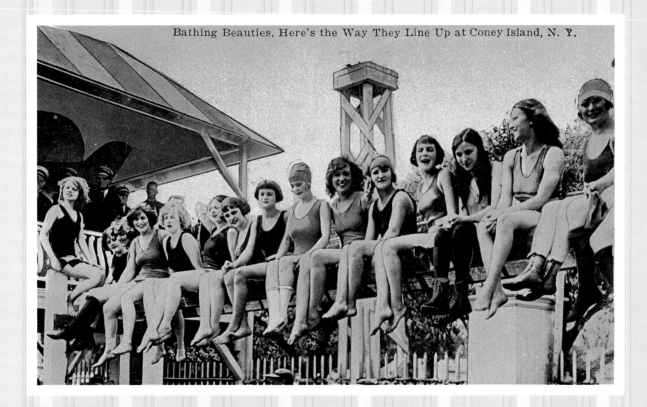

Bathing Beauties, Here's the Way They Line Up at Coney Island, N. Y.

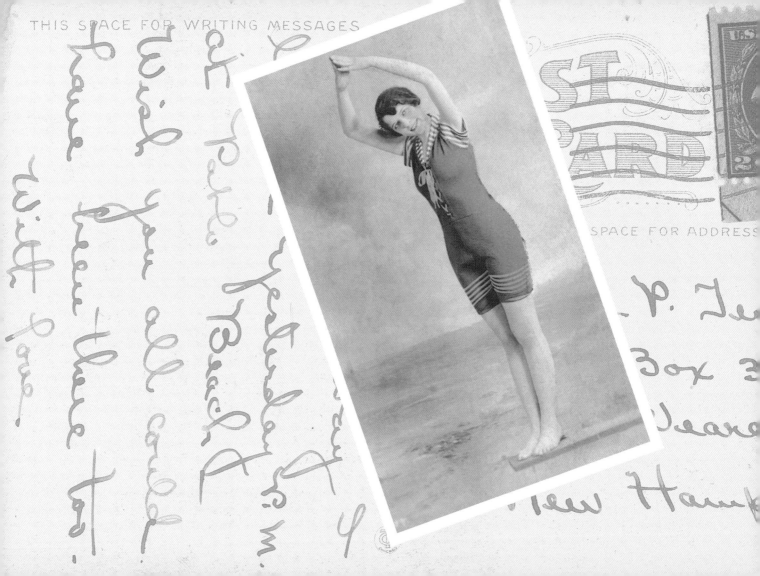

SPACE FOR ADDRESS

These images do not tell the whole story; to be certain, the bathing beauty soon became a commodity in cigarette and soft drink ads, real estate offerings, and travel brochures. A June 1940 Coca-Cola advertisement featuring a comely woman clad in a bathing suit and high-heeled shoes suggested, "Make your place in the sun a cool one." Bathing beauties sold films and beach travel, especially to Florida. And, to be sure, most of the ads and many of the postcards carry erotic underpinnings: beautiful, scantily clad women luring men to try or buy.

Yet, in these postcards and photos one can also find a wholesomeness, a celebration of womanhood, and an ode to a pastime and a place: the beach. To look at these postcards and photographs is to see history unfold. From the very first card I collected, I was captivated by the images of innocence and delight I found in these early twentieth-century photographs, these pictures that wordlessly tell a tale of American women.

under wraps

Through most of the nineteenth century, women at the beach were corseted and covered from head to toe. Women wore wool dresses, stockings, corsets, hats, and gloves, leaving virtually no skin visible. While their male counterparts stripped down to near-nothing to go in the water, women, weighed down by yards of fabric, were forced to wade in delicately, gingerly—if at all.

Modesty was required of rich and poor women alike. In fashionable Newport, Rhode Island, a white flag was hoisted at times when full regalia—and full coverage—were required. A sign posted at the Surf House Restaurant at Coney Island (where suits could be rented for twenty-five cents) warned that "Bathers Without Full Suits Positively Prohibited By Law." At Atlantic City and many other popular beaches across the country, censors roved, ready to cite those bathers whose costumes were too revealing.

By the end of the nineteenth century, innovations in swimwear included shorter dresses with bloomers underneath and "The Princess," a one-piece costume of a top attached to bloomers, with—daringly enough—no skirt.

Bathing at Long Beach, Cal.

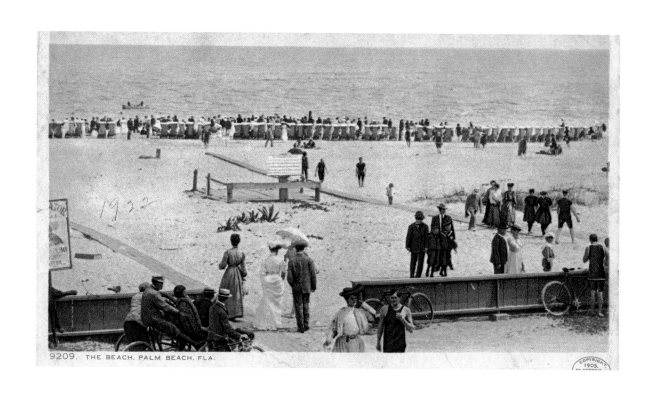

9209. THE BEACH, PALM BEACH, FLA.

20

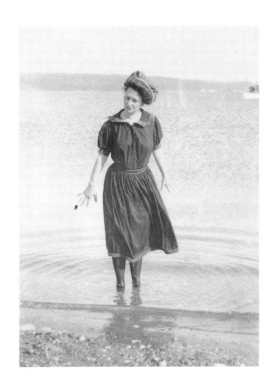

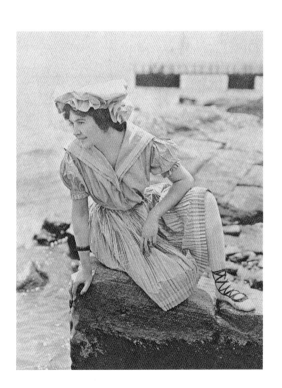

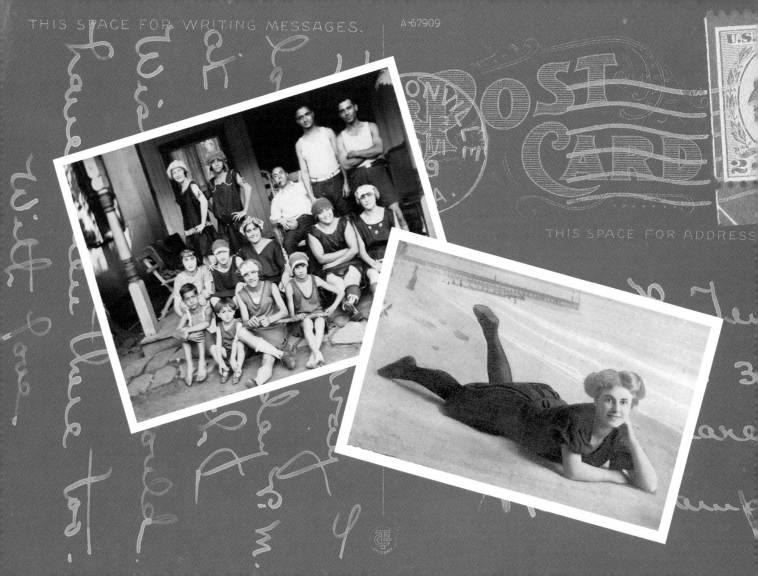

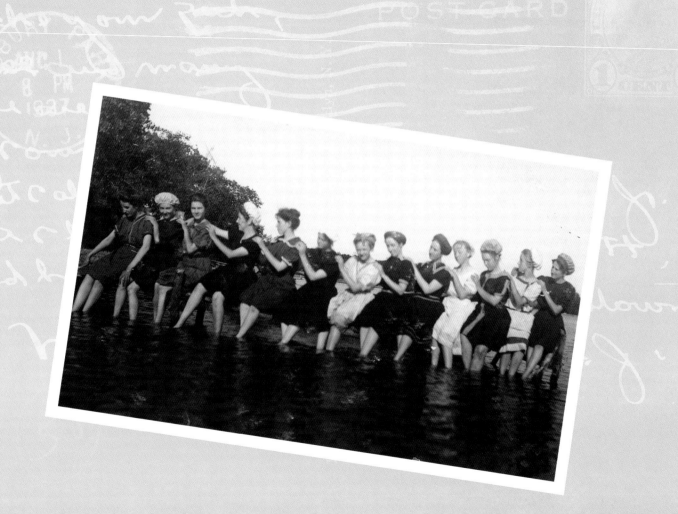

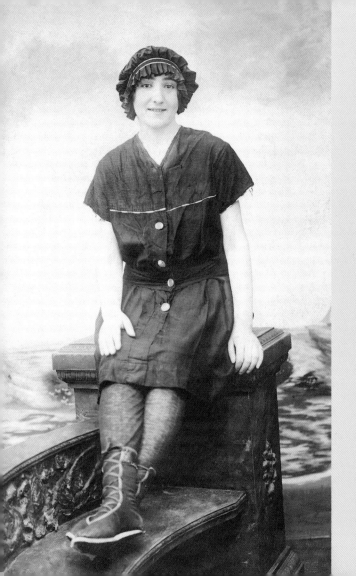

Blouse and **bloomer suits** may be worn with or without stockings, provided the blouse has **quarter-arm sleeves** or close-fitting armholes, and provided bloomers are full and not shorter than **four inches** above the knee.

—American Association of Park Superintendents, May 1917

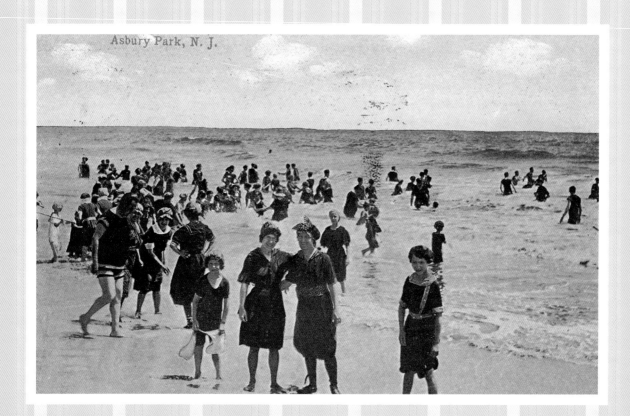

Asbury Park, N. J.

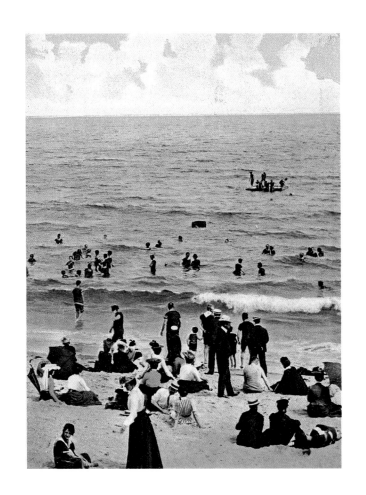

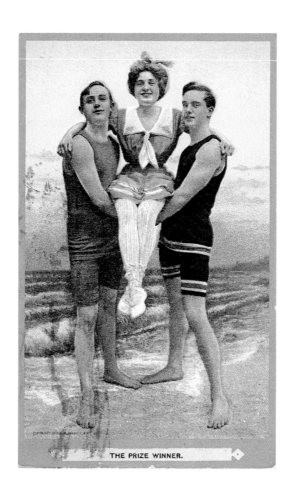

THE PRIZE WINNER.

women in suits

"I guess the biggest change of all is in bathing suits," said Mary Anne Meecham, an Irish immigrant interviewed in Boston as part of the Federal Writers Project in June 1939. "The girls today wear a handkerchief and a pair of short pants, but I remember my first suit was of wool, dark blue, all trimmed with braid and big bloomers underneath and long stockings, with laced up shoes . . . it's a wonder that the weight of 'em didn't drown me."

The swimming star Annette Kellerman was renowned for her decision to throw off the traditional heavy garb worn by women as they "bathed" and wear a man's form-fitting and comparatively skimpy one-piece suit. "I can't swim wearing more clothes than you hang on a clothesline," she once declared. An Australian by birth, she moved to England and then to America with her high-dive and swimming act. In 1907, she was arrested at Revere Beach, just north of Boston, for indecent exposure. Later Esther Williams portrayed Kellerman in the 1952 film, *Million Dollar Mermaid*.

In 1913, Carl Jantzen and John Zehntbauer began the mass production of the swimsuit. They made and marketed a ribbed, knitted, one-piece bathing suit that weighed two pounds dry but a hefty eight pounds when wet; it was not the final solution, but it did change fashion history. Other manufacturers followed quickly. Within a decade, the swimsuit was pared down and streamlined, even to the point that one model was called the "Bauhaus," an ode to the minimalism of modern architecture.

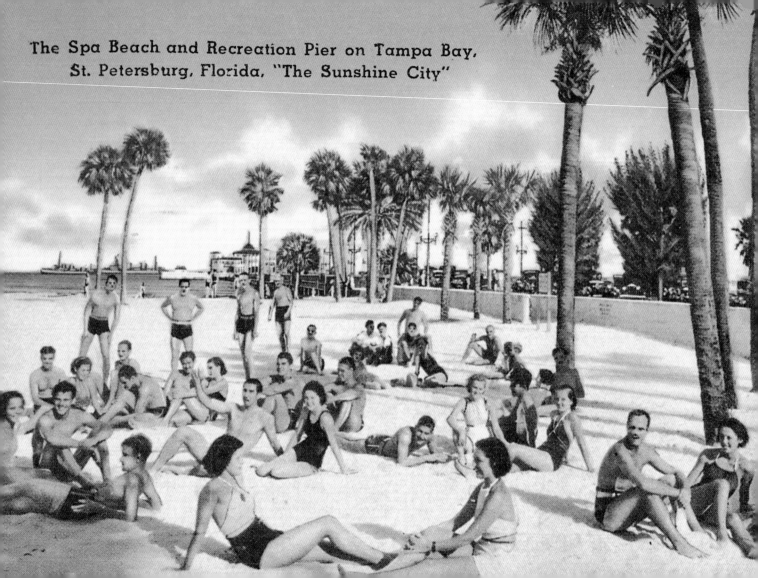

The Spa Beach and Recreation Pier on Tampa Bay,
St. Petersburg, Florida, "The Sunshine City"

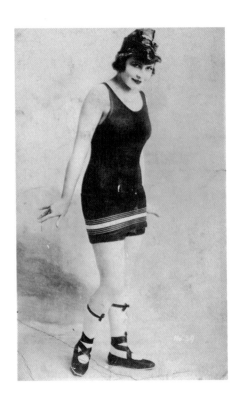

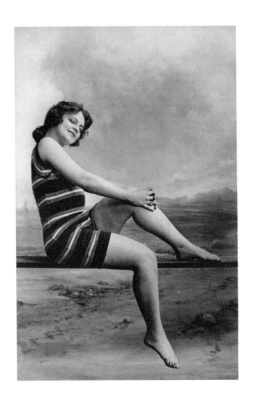

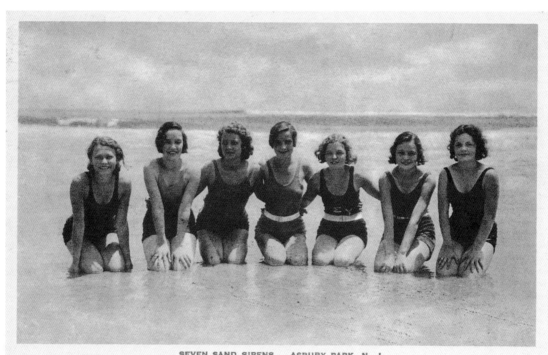

SEVEN SAND SIRENS ASBURY PARK, N. J.

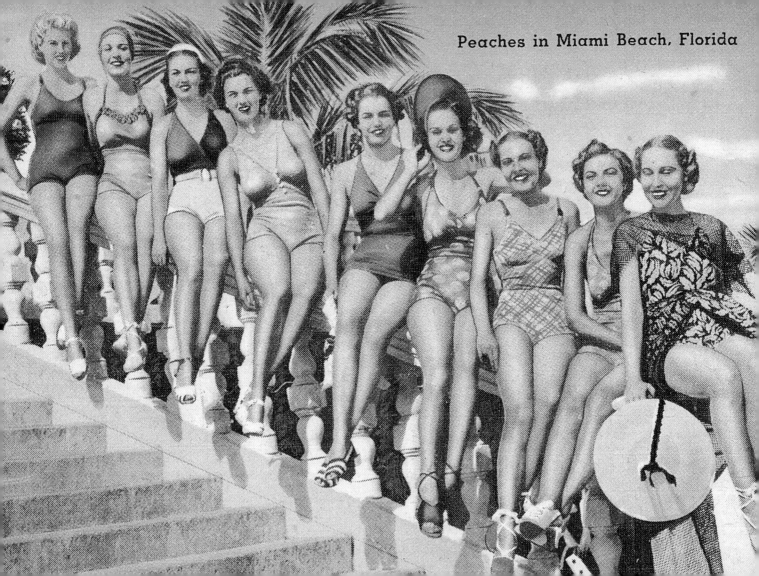

Peaches in Miami Beach, Florida

In 1923, Jantzen swimsuit officials headed off from Portland, Oregon to a convention and took along "diver girl" decals that they passed out at stops en route. By the time the train arrived in Washington D.C., it was being called "The Diving Girl Special."

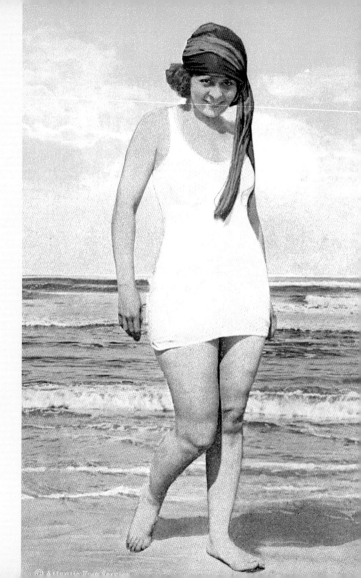

POST CARD

UNITED STATES
FRANKLIN
1 CENT

ASBURY
8 PM
1927
N. J.

Brooklyn, N.Y.

Post

Merrill.

50

Tard.

1 CENT

Dear Frith,
Will look
for you a
Sund
morning. From
Sam

Uhrmann

Jefferson St

Philadelphia

18

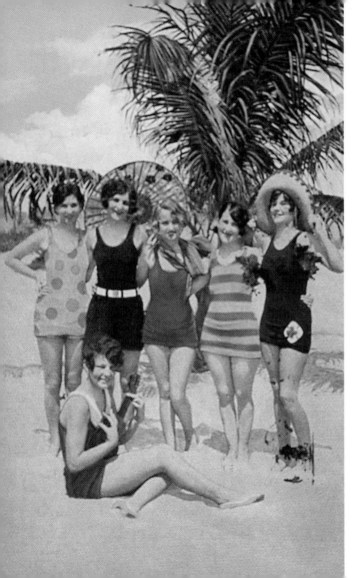

"Be attractive while you're active," exhorted a Jantzen swimsuit ad in 1938. "Never before have swim suits been created that fit so perfectly, that mold and hold the body so nearly to the natural lines of youth."

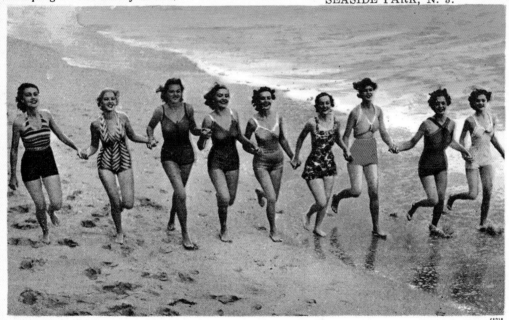

Romping on the Sunny Shore, SEASIDE PARK, N. J.

65218

group shots
Two by Two, Three by Three, and More

From the late nineteenth century on, beach mania ruled as rich and poor alike set out for the sun. These were largely camera-mad and fun-seeking vacationers ready to document the hours, the days, the weeks of their escape from their everyday lives. The pocket Kodak camera, released to the public in 1895, helped them do just that, particularly when, five years later, the first mass-marketed Brownie camera became available at the cost of $1.00. By 1906, a "folding pocket camera" took photographs that could be printed as postcards.

The commercial postcard companies were hard at work lining up rows of bathing beauties, posing them as they played leapfrog or tug-of-war, and capturing images of them frolicking in the sea or basking in the sun. Once the photo had been taken, a good shot of a group would be used repeatedly. A postcard from Old Orchard Beach, Maine could be reprinted for Revere Beach, Massachusetts; Clinton, Connecticut; Asbury Park, New Jersey; or Rehobeth, Delaware. A sun-tanned and bathing suit-clad line-up from Miami Beach might reappear on a postcard from Ocean City, Maryland. Fact and fiction merged as photographers documented the fantasy of bevies of women at the beach.

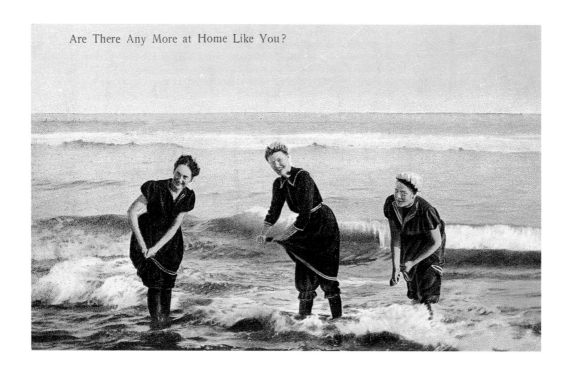

Are There Any More at Home Like You?

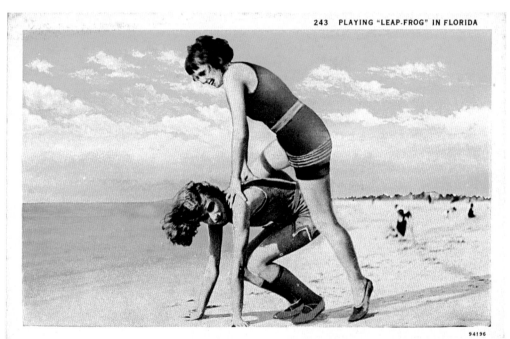

94196

41

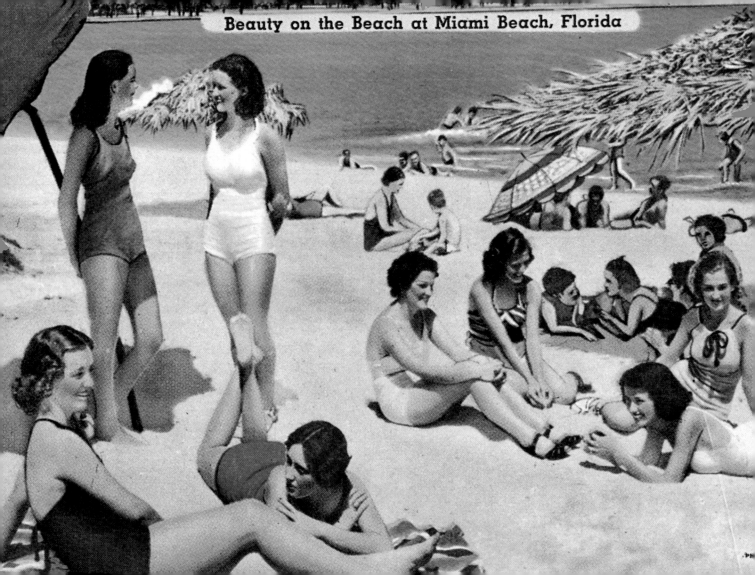

Beauty on the Beach at Miami Beach, Florida

You couldn't pick up a paper in
the **United States** without seeing
a picture of bathing **beauties,**
standing by the beach, never
getting wet… And **Miami Beach**
all of a sudden became the
place to go.

—Howard Kleinberg, author of *The American Experience:
Mr. Miami Beach,* Interview on PBS, 1998

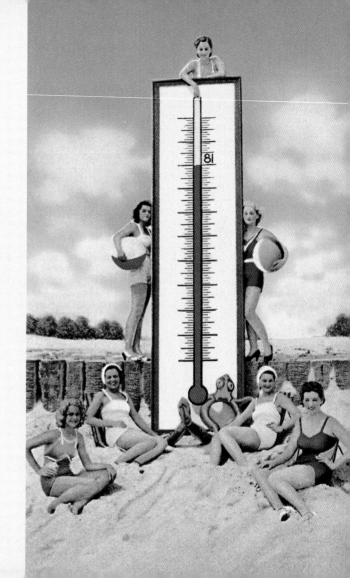

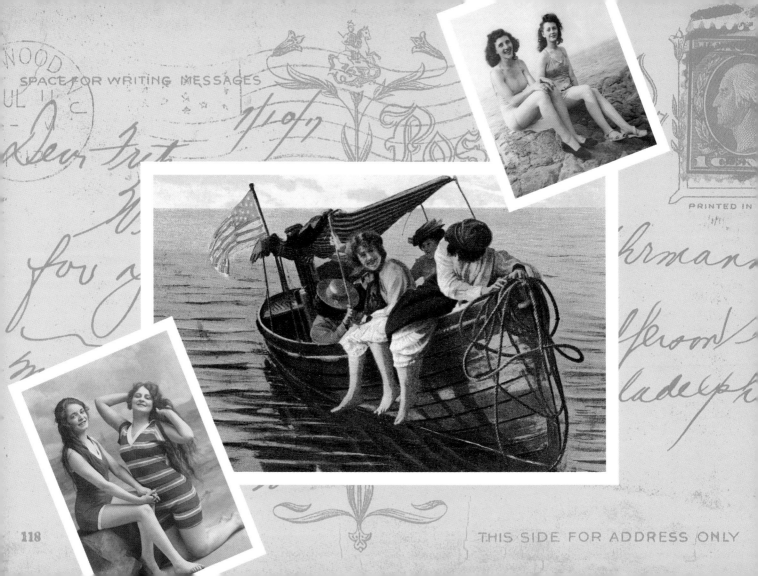

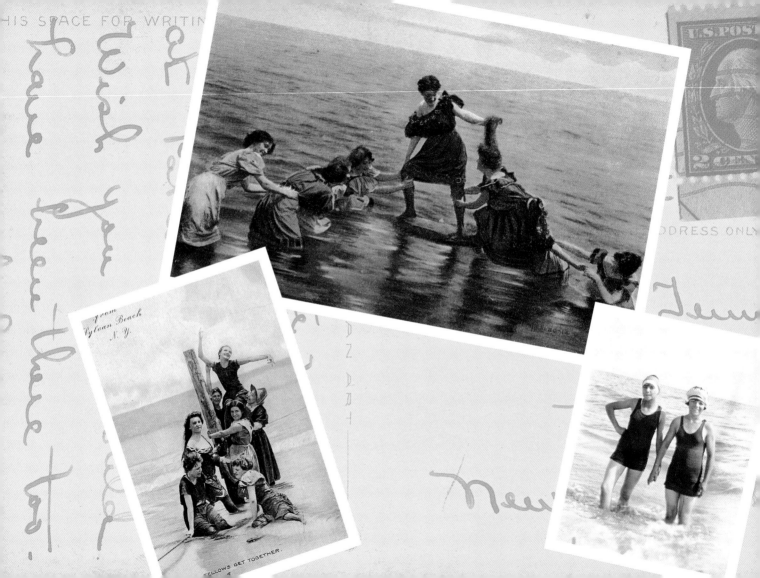

FELLOWS GET TOGETHER.

From
Sylvan Beach
N.Y.

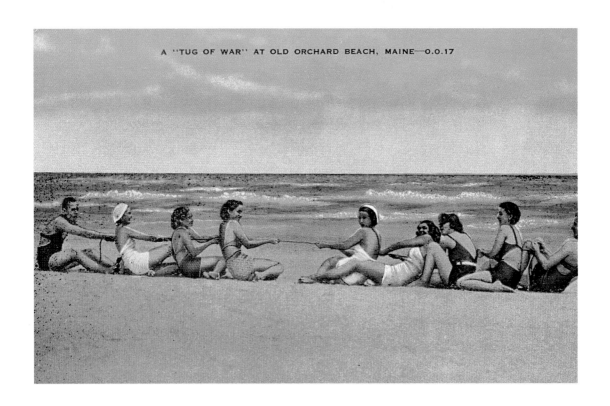

A "TUG OF WAR" AT OLD ORCHARD BEACH, MAINE—O.O.17

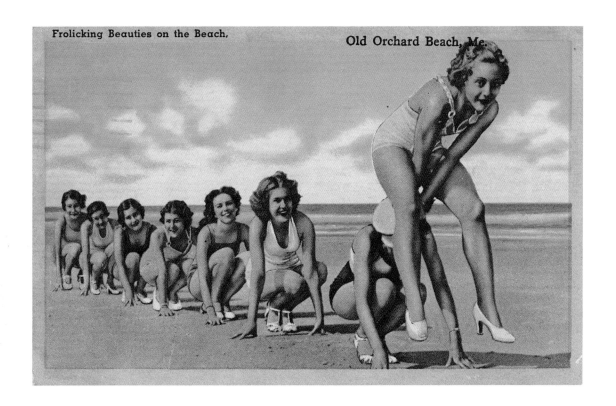

Frolicking Beauties on the Beach.

Old Orchard Beach, Me.

47

in the shade

Umbrellas actually have an ancient history; archaeologists have uncovered evidence of their use in Egypt, Assyria, Greece, and China. "The parasol was reserved exclusively for the monarch and is never represented as borne over any other person," wrote R. L. Chambers in his *Book of Days*, published in 1864, by which time European and American gentlemen carried them for rainy days. But, the parasol soon had its day in the sun once again.

In the late nineteenth and early twentieth centuries, women desired pale, creamy complexions. Though the beach-going garb of the time was probably sufficient to ward off the sun's rays, parasols became fashionable accessories for days at the seashore. Sunbathing—and its obvious corollary, sun-tanning—were not acceptable until photographs of a bronzed Coco Chanel appeared in 1923. Only then did shade, once a seeming necessity, become an option.

In the early years, bathing suits were generally sober in hue, usually black or navy blue; so, the beach umbrella became the primary canvas for self-expression. Stripes and vivid prints abounded. Soon, the image of the bathing beauty and the beach umbrella were intertwined as tightly as sand and surf. Plus, with their bright colors, umbrellas were flashy artifacts of the Jazz Age.

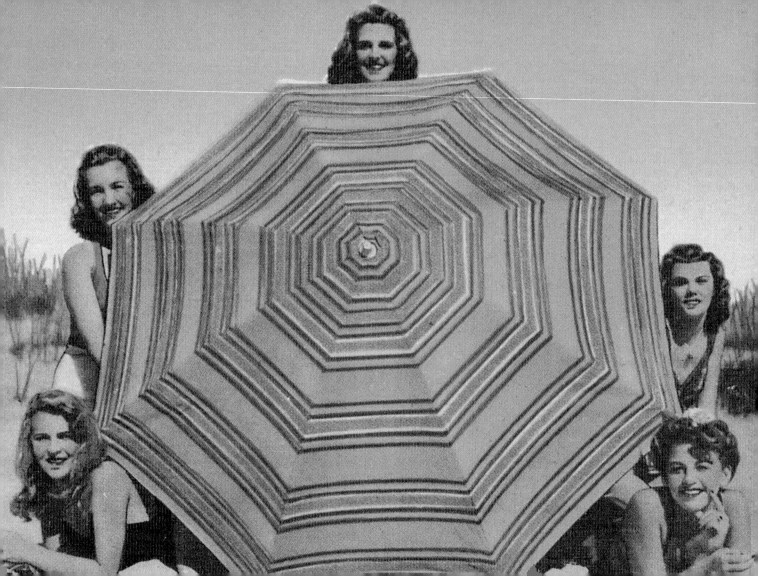

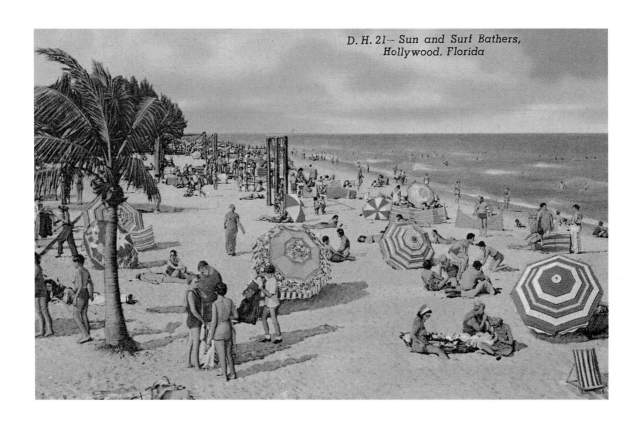

D. H. 21— Sun and Surf Bathers, Hollywood, Florida

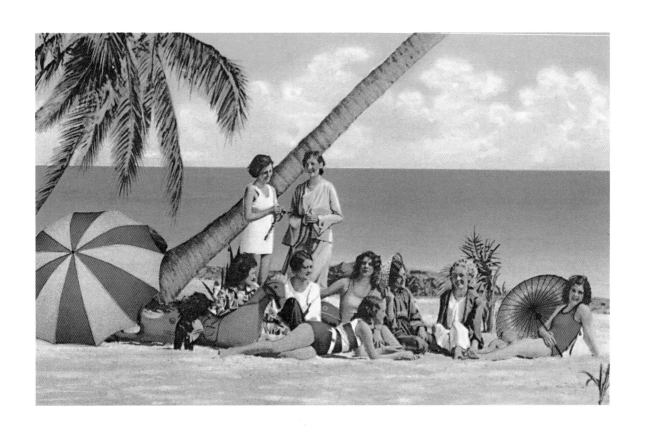

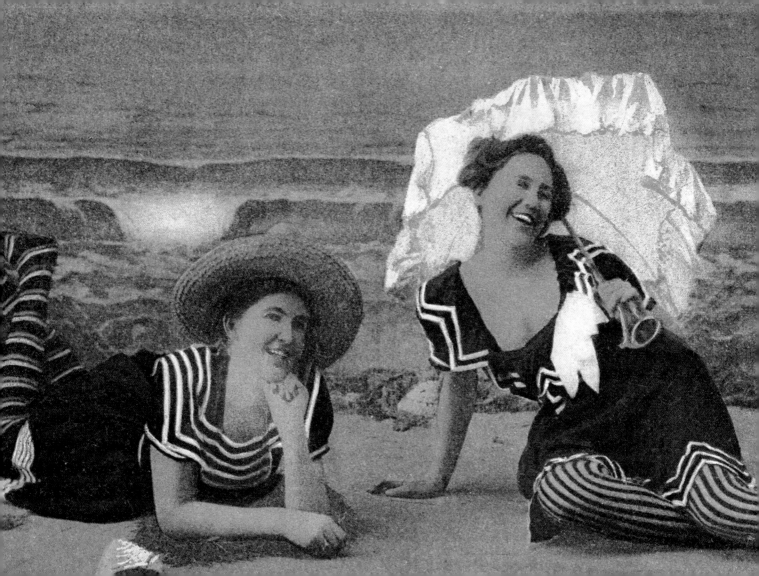

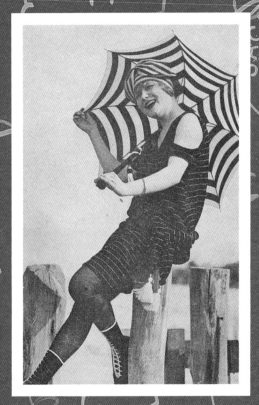

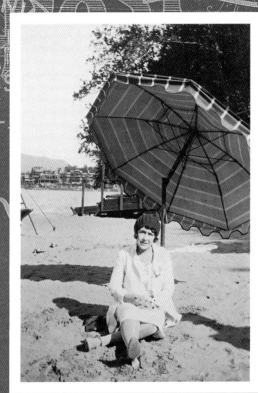

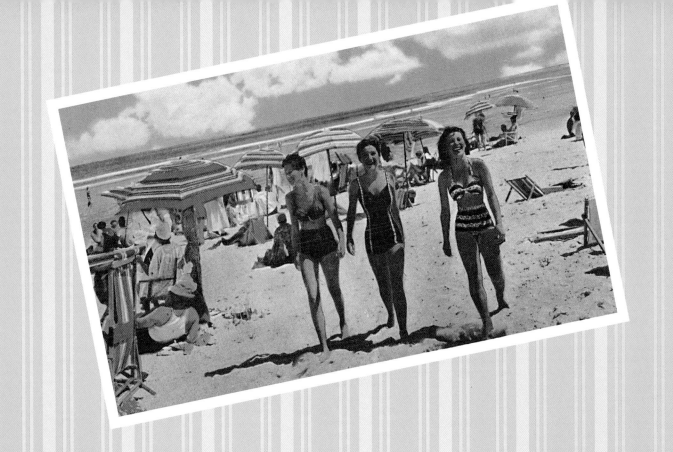

Make your place in the sun a cool one.

—Coca-Cola advertisement, 1940

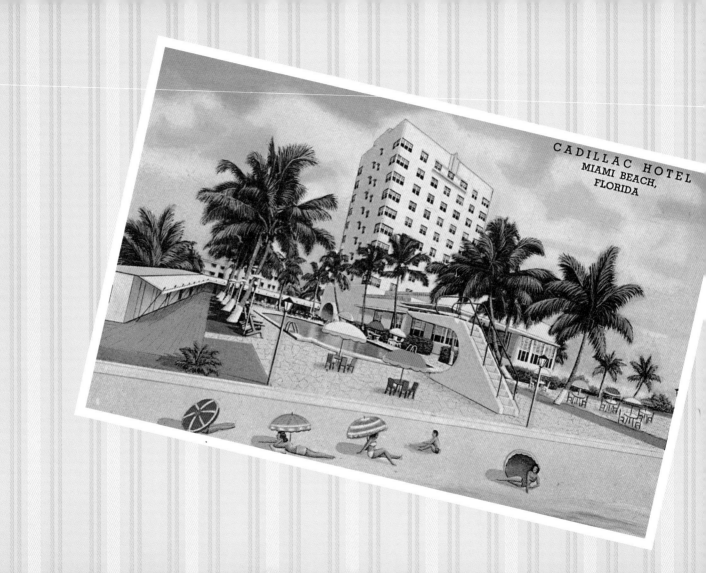

CADILLAC HOTEL
MIAMI BEACH,
FLORIDA

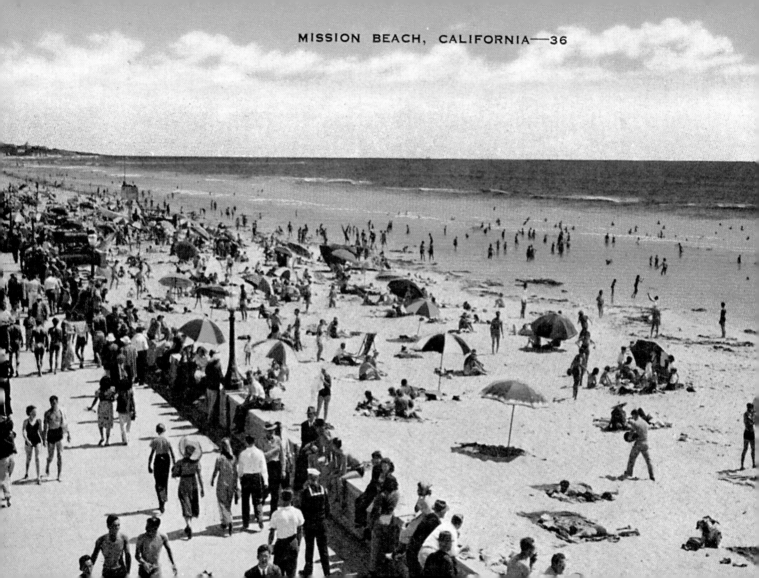

MISSION BEACH, CALIFORNIA—36

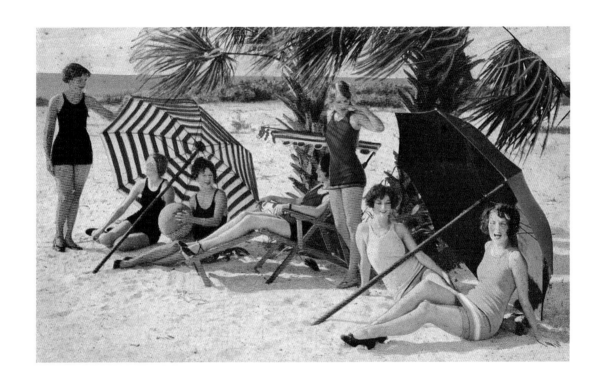

the water's fine

Though the Greeks and Romans were great swimmers, the sport fell out of favor over the centuries. When it did revive, it was a sport largely for men. Women were too weighted down by both social mores and their custom of dress to be able to swim with any efficacy. At the beginning of the twentieth century, Annette Kellerman became a one-woman propaganda machine for the sport. "I am not trying to cut men out of swimming," she said. "There is enough water in the world for all of us."

Soon swimming and suffragism became synonymous—at least with a certain outspoken cadre of women. Swimming, real swimming (as opposed to the hesitant bathing done by previous generations), was a symbol of the newly independent American woman, one who could compete with men on solid ground or in the water. Swimming became an Olympic sport in 1896, and by 1912, women competed in the event.

Swimming was also an art form. The Olympian Eleanor Holm emerged in the late 1930s as America's premier water ballerina, the star of Billy Rose's "Aquacade," and she was followed in both live performances and on film by others, most notably Esther Williams. In less than half a century, women had claimed swimming as their own.

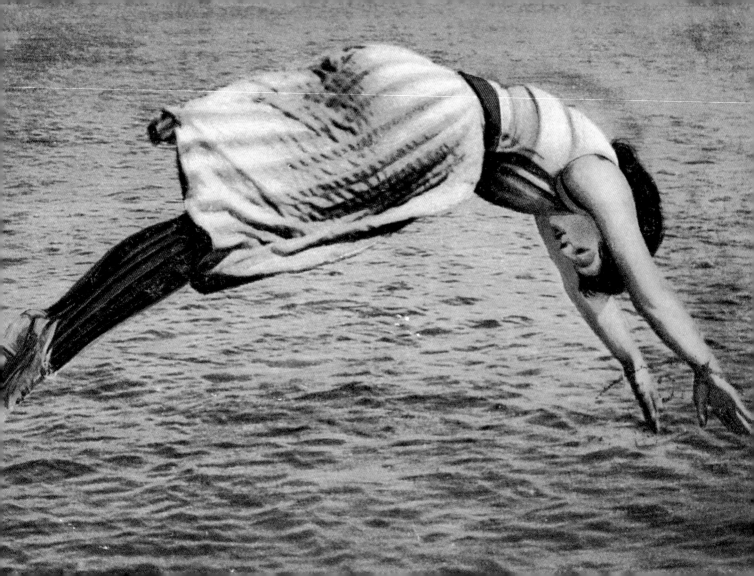

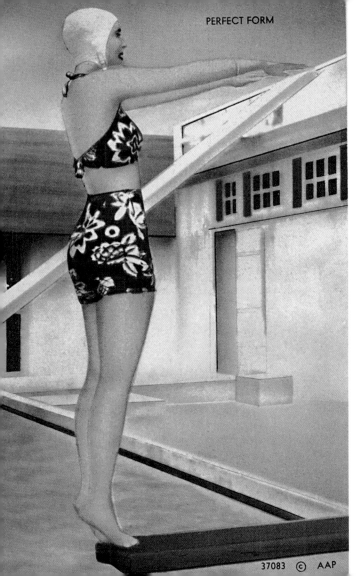

PERFECT FORM

37083 © AAP

But as **men can indulge** in so many sports where women make a poor showing or **cannot compete** at all, swimming may well be called the **women's sport.**

—Annette Kellerman, *How to Swim,* 1916

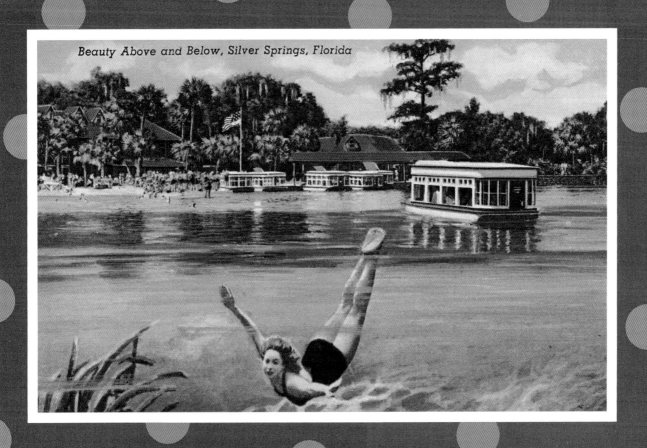

Beauty Above and Below, Silver Springs, Florida

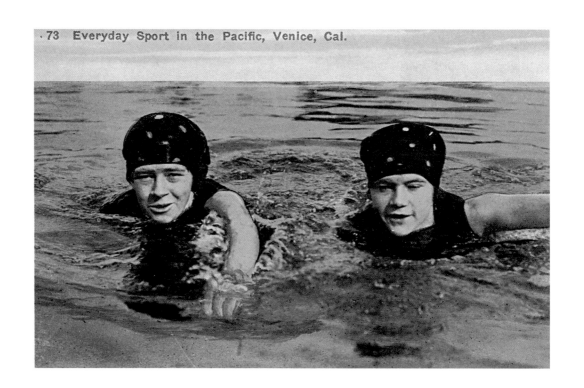

73 Everyday Sport in the Pacific, Venice, Cal.

This is the Life.

DRESS ONLY

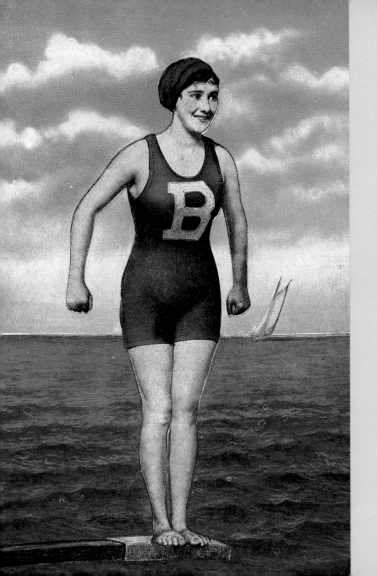

"I wouldn't dream of dunking my head four performances a day without benefit of a bathing cap," said "Aquacade" star Eleanor Holm in a 1940 advertisement for Vaseline Hair Tonic.

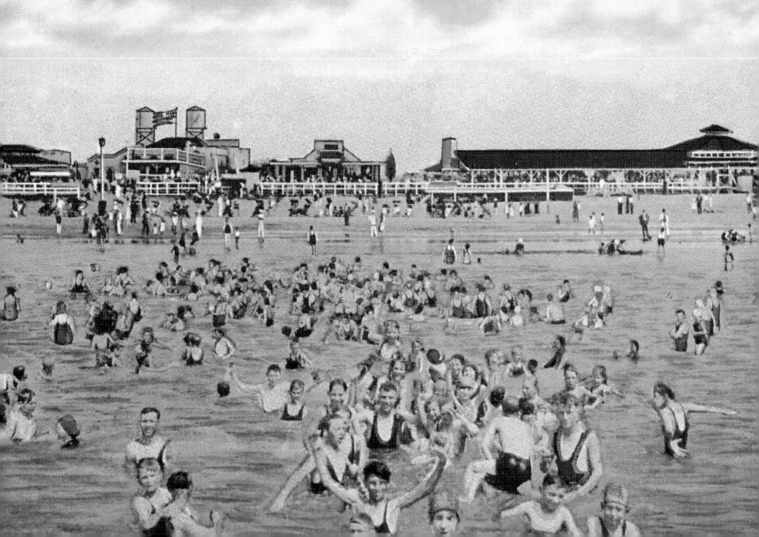

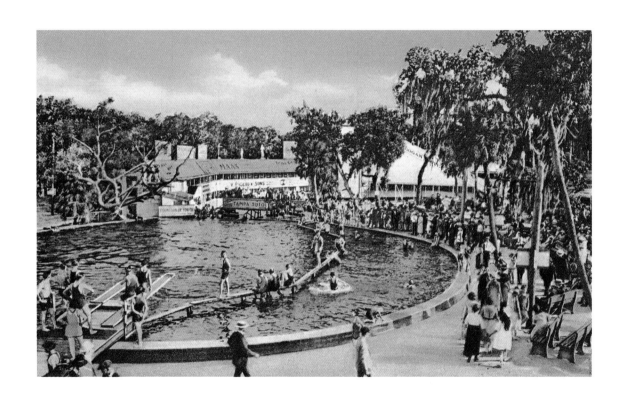

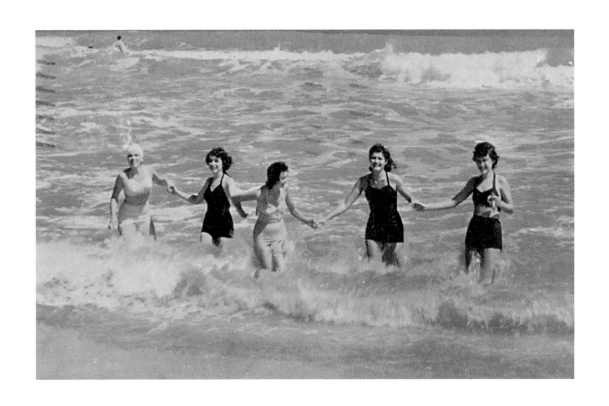

wish you were here

"This is the way I looked yesterday P.M. at Pablo Beach. Wish you all could have been there too," wrote Wilma to Fred P. Tenney in August 1919. It's the kind of message repeated on many a bathing beauty postcard. Whether the image of the bathing beauty was flirtatious, earnest, coy, winsome, or cunning, the postcard, once sent to a family member or a friend, inevitably conveyed the notion of an escape to the sea, a carefree holiday.

Indeed, by the end of the nineteenth century and well into the twentieth, beaches offered an array of enticements to the daytripper, weeklong vacationer, and summer or (in the case of Florida) winter resident. There were band concerts and dances, high-diving horses and sideshows, pageants (both formal and impromptu ones), and parades.

And there was more: from Orchard Beach, Maine, to Venice Beach, California, the amusements abounded. The world's first roller coaster opened at Coney Island in 1884, bearing the name "Gravity Switchback Pleasure Railway." Others soon followed at beaches from Atlantic City to Chautauqua to Conneaut to Cedar Point-on-Lake Erie and beyond—as far as Redondo Beach and Santa Cruz in California.

The beach offered solitary pursuits as well, like collecting shells and fishing, and these were duly documented in photographs and postcards. Indeed, whether it was high-flying roller coasters or the quiet of an oceanside stroll, a day at the beach was indeed something to write home about.

Dear Mother
This is me Yours S.L.C

305
A SUN BATH

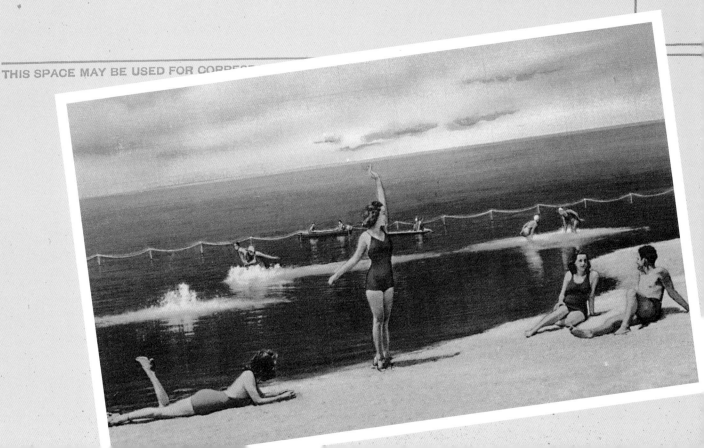

Take your pick
there are many
more here.
If I choose the one
that catches my eye.
is a charming
red head.

Merritt.

Mr. Wm Price J.
Chestnut H
Bordento
N. J

ASBURY P.
AUG 1
8 PM
1927
N. J.

50

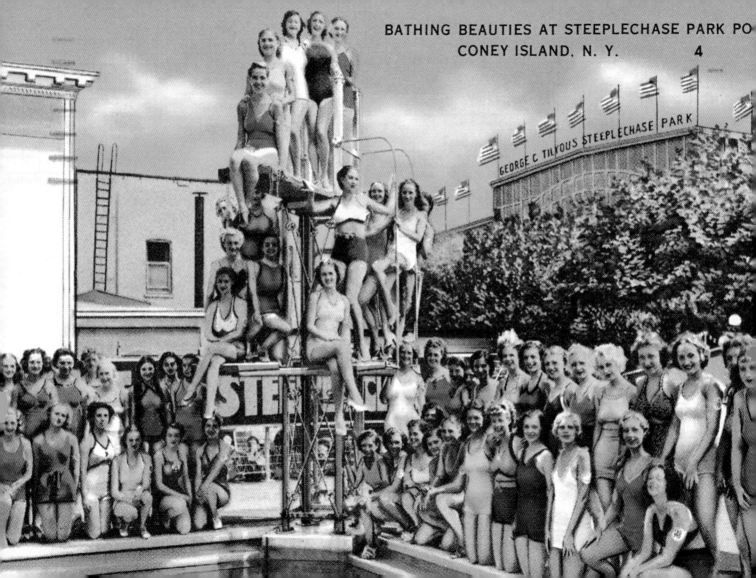

BATHING BEAUTIES AT STEEPLECHASE PARK PO
CONEY ISLAND, N. Y. 4

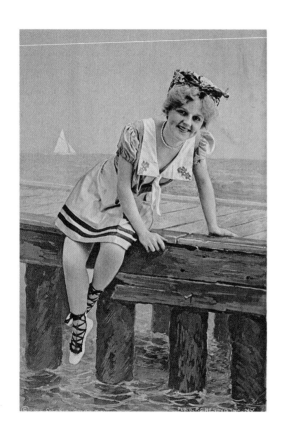

"Have a Row with Me" in Florida.—5

The Belle of the Beach and the Bell-Buoy

Oh how delightful 'tis to stroll

Where Murm'ring winds and waters meet,

Marking the billows as they roll

And break resistless at your feet

—H. DeMarsan, "Rockaway," nineteenth century

The Pier, Old Orchard Beach, Me.

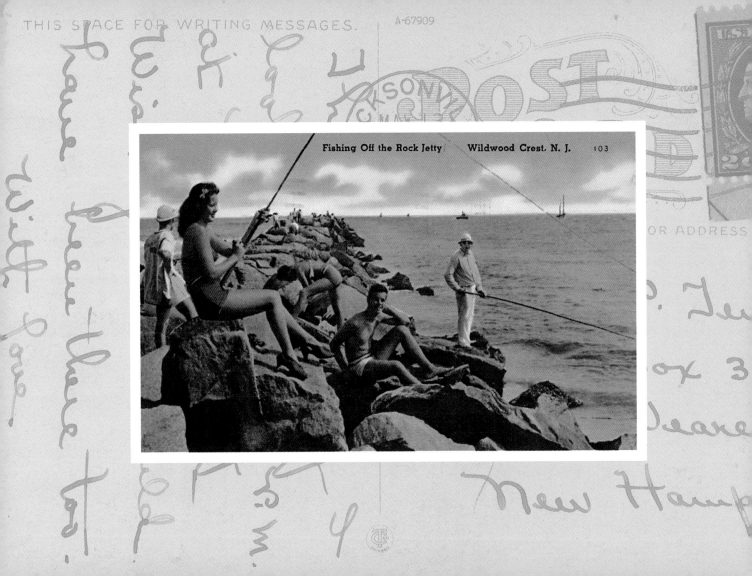

Fishing Off the Rock Jetty Wildwood Crest. N. J. 103

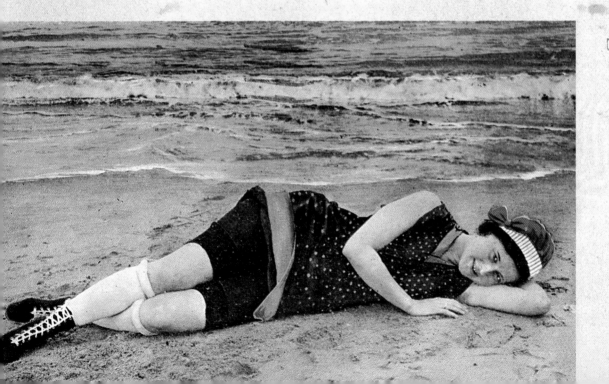

Mitchell

Post Card

Dear Annie,
Hello! How
are you? I
wish you and
Phil were here
to play on our
beach with me.
Love
Cousin Helen.

POST CARD

Miss Annie K.
2111
Washington
Altoona
Pennsylvan

BEVERLY, MASS.

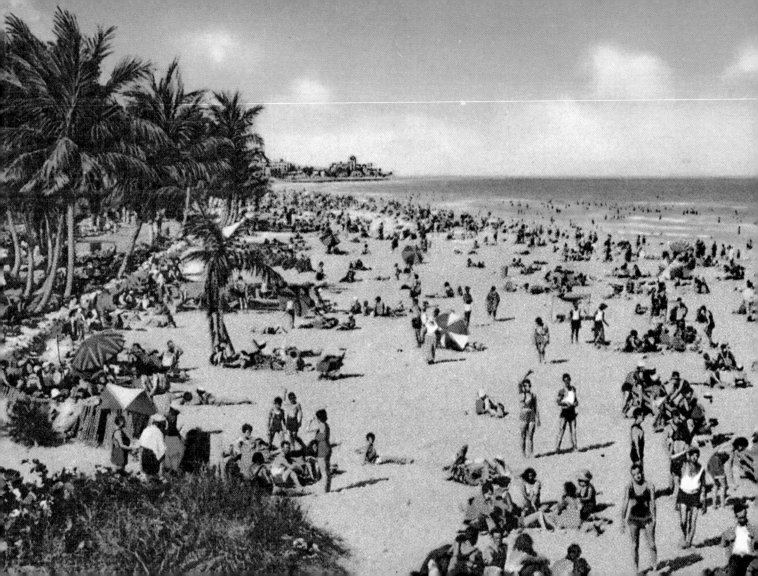

credits

Asheville Post Card, Asheville, N.C., Frontispiece, 49

Florida State Archives, 5, 36

CT American Art Colored/Asheville Postcard, Asheville, N.C.,
 Contents (left)

American Art Colored, Contents (center)

Tichnor Quality View, Tichnor Bros., Boston, Mass., Contents
 (right), 29, 32, 37 (left), 42, 47, 75, 76

Curteich Co., Inc. Chicago, Ill. (credits read: CT American Art
 Colored, CT Art-Colortoned Post Card, Genuine Curteich Chicago
 CT Art-Colortoned), 9, 33, 37 (right © Burgert Bros.),
 41, 43, 50, 51, 55, 61, 66, 70, 77, 79

Robbins Bros., Boston, Mass., 12

Coppergraphs, Made in Los Angeles by Phillips Printing, 19

WG MacFarlane, Publisher and Importer, Toronto, New York and
 Buffalo, 22 (right)

Whitely Studio, Atlantic City, N.J., 23

The Asbury Park 10 & 25¢ Store, Asbury Park, N.J., 25

The Metropolitan News Co., Boston, Mass., 26

"MY" Place, J.L. Pyka Jr., prop., Sealy, Tex., 30

Glaser's Gift Shop, Inc., Boardwalk, Asbury Park, N.J., 31

M. Rieder Publ., Los Angeles, Calif., 40

Atlantic Post Card Co., Portland, Maine and St. Petersburg, Fla.,
 46, 57

Dade County News Dealers Supply Co., Miami, Fla., Photo by
 Karlburg, 50

A "Colourpicture" Publication, Boston, Mass., 54

Hopkins News Agency, San Diego, Calif., 56

Natural Color Post Card Made in USA by EC Kropp Co.
 Milwaukee, Wisc., 56, 65

Illustrated Postal Card Co., N.Y., Leipzig, 59

Arthur Allen Peterson, Greenland, N.H., 60

The M. Kashower Co., Los Angeles, Calif., 62

The Pacific Novelty Co., San Francisco, Calif., 64

A Mike Roberts Color Production, Berkeley, Calif., 67

Rialto Post Card, New York, N.Y., 69

Edward H. Mitchell Publisher, San Francisco, Calif., 74

All efforts have been made to identify the photographer, producer or manufacturer of the postcards and photographic images in this book and to give exact credits. The author apologizes for any inadvertent omissions. Many early images carry no credits; others were produced by more than one company. Likewise, though most of the images were produced between 1890 and 1940, exact dating is impossible. Many popular postcards were kept in circulation for decades, with bathing suits updated by airbrush painting as styles changed.